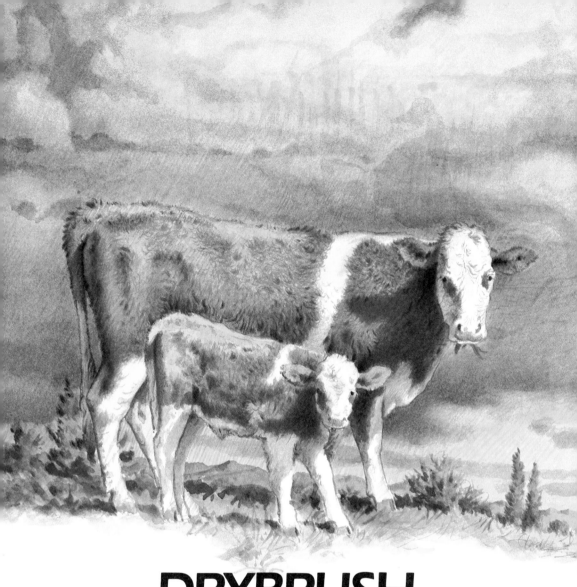

DRYBRUSH
WATERC[OLO...]

BY GENE [...]

Walter Foster Publishing, Inc.
430 West Sixth Street, Tustin, CA 92680-9990

Table of Contents

Foreword

I am excited, thrilled and feel highly privileged to be able to write the foreword to this compelling little book. I watched and participated in the "birth pangs" as the artwork and instructional material developed. I think you will find this to be a unique teaching guide, as well as an energetic and fresh approach to the wonderful medium of watercolor.

Drybrush Watercolor is the culmination of years of experimentation by the author-artist, Gene Franks. He has extensively tested every kind of paint and surface to eventually arrive at the remarkable system you will experience on these pages. In fact, most of what you see here was developed and enhanced just for this book. I trust his discoveries will enlighten you.

This painter is a master of technique. It's what he is known for. Never satisfied with the mediocre, he presses on to find a better way to execute each painting. Of all the mediums he is skilled at and teaches, this is his favorite and best. Rest assured you are studying with an artist unexcelled in the specialized field of drybrush watercolor.

Not only is Gene concerned with the permanency of his painting and creativity of his output, but he wants his work to speak for the solid values of life which are being lost in this generation. He prefers that his artwork decorate the heart first, then the home. He believes in the importance of family, community, and faith in God.

Raised in the rural midwest, Gene finds it very natural to paint the basic things of life; thus, the nostalgic Americana theme begun in his first book, **Pencil Drawing,** is continued in this volume.

Those delicate pencil renderings are outdone only by the sensitive, lovely colored drawings found here in **Drybrush Watercolor.** This is, indeed, his finest work yet.

Are you ready for a new surge of inspiration? Are you looking for that new sparkle to enhance your own painting? I believe you have found it! This artist's enthusiastic, positive teaching is sure to infuse you with excitement. As you try drybrush, you're in for an exhilarating experience. Enjoy!

Jane W. Franks

What is Drybrush?

I have come full circle. For years I experimented with all the water-based paints and many surfaces. During those early years, I discovered egg tempera, a method of mixing egg yolk with paint and using the brush semi-dry. Fascinated, I studied it diligently. The knowledge I gained from attempting to master this difficult technique was immeasurable. It improved my work in other mediums. It especially helped my watercolor techniques. I then realized that water-base paints are more versatile than I had thought. To make a long story short, I started using acrylics, gouache, casein, and transparent watercolor in the egg tempera fashion.

Years passed and I began teaching this technique, using various water-base paints, calling it "drybrush watercolor." I seemed to be headed someplace with it, but didn't know where. I would say to my wife, "I wish I could paint like I can draw." People commented that my drawings were looser and more appealing than my paintings — the real me. I worked hard until the combination of technique, paint, and surface all started coming together.

Finally, settling on transparent watercolor, which I use with my special imported papers, I discovered a medium that allows me to simulate my refined pencil technique (see **Pencil Drawing,** my first book), only in color. It has come to suit my needs above all other media and I am very excited about it. My drybrush is literally drawing with paint. If you like to draw, but want color in your work, this technique is for you!

I borrowed the term "drybrush" from the pulp magazine era of the 1920's to 1940's, when American illustrators used India ink to produce their black and whites for publication. They would drag the brush across textured paper to create a broken tonal effect for shading. They called this technique "drybrush."

The classic example of this wonderful medium has been handed down to us from the great master and German artist, Albrecht Dürer, who lived in the late 15th and early 16th centuries. Dürer portrayed his love for nature in "Large Tuft of Grass" and "Young Hare," by painting every blade of grass and each hair on the animal's coat. Both of these paintings, as well as his other watercolors, show amazing detail and have a delicate, poetic beauty that people have come to love. Maybe he didn't call his technique "drybrush," but that was what he was doing. There are well-known artists today using a similar method with a high degree of success.

These experts inspired me to develop what you see here. While I don't profess to be the final authority, or pretend to be the originator of this technique, I do believe I carry watercolor a step further in execution than many artists by adding extreme realism for a combination tight and loose "look" to my work. While my backgrounds are usually abstract, the subject itself will be painted in minute detail, using the brush as a drawing instrument. Drybrush, as taught in this book, is actually a series of hatches, strokes and light washes woven together. This system will be explained more thoroughly later on.

I think that drybrush is for the individual who desires to develop a highly personalized and sensitive art style. Once you understand the natural behavior of the paint with the paper and the handling of the brushes, you can develop a "look" that is totally your own — romantic, fantasy, old world, or contemporary.

The distinctives of this medium point to the benefits for professional and hobbyist alike. First of all, drybrush is versatile. It is used transparently for washes — the vivid rich, clean glazes giving a luminous effect; and it can be combined with opaque white for final accents. The medium is suitable for almost any subject — animals, flowers, portraits, still life — for finished work and especially vignettes.

Drybrush is also convenient. It's a simple method to set up and use. Fast, easy cleanup with water makes it a natural for either outdoor or indoor work.

The paint is economical since it is used in thin washes and goes a long way. It can be softened after drying on the palette, so there is little waste. And, all procedures can be accomplished with three to five brushes, keeping expenses down further.

Drybrush is an excellent illustrator's technique. As you can see from my work in this book, it reproduces well, an important principle for all artists to consider.

Finally, students love the method. Mine are doing well — selling their work and winning ribbons. You can, too. It's a medium to grow with.

Yes, this is a different way of using watercolor, and that's why I like it. The artist who explores the use of materials in new ways is the one who creates something lasting and original. You will be delighted that you have decided to try this inspiring medium.

Learning to See

Looking and seeing are two different things. Everyday, we look at objects around us —buildings, trees, sky, landscapes of all kinds; and people — young and old, black and white. How many of these do we really see?

Do you observe the lavenders, yellows, and grays, as well as the blues in the sky; or the blue-greens, yellow-greens, and browns, as well as the leaf greens in foliage? Do you notice the haze on the mountains or all the golds in dried grass? How about the character in the old face or the innocence of the Indian child? Do the eyes express fear, love, or sadness?

A good way to develop your artist's "sight" is to study the work of great artists. If you live near major galleries, take advantage of repeated visits to the same paintings. If not, study reproductions in quality art books found in local bookstores and libraries. Review them again and again. When traveling, include a museum and a gallery or two in your itinerary. You will want to peruse the paintings in depth. Bring a magnifying glass along to examine how the strokes were made and how they stand out from each other. How did the artist accent his colors and play light against dark? Did he do the painting in the morning, evening or at midday? As you "read" these masterpieces, you will glean knowledge to help you improve your own work. Make notes and sketches. Then, go home and experiment with some new techniques.

You will be in the company of great artists when you study the work of others. Raphael studied Michelangelo, Rembrandt studied Raphael, and everyone studies Rembrandt. Norman Rockwell had Rembrandt's prints tacked up around his studio.

By observing both nature and art, you may find a little inspiration that could spark big things for you. Time spent learning to "see" can reap great rewards and make you a better artist.

The Work Area

The work area need not be elaborate. Have a small table or easel against which you can rest your board, with your paper taped to it, in a slanted position. The work should be at a right angle to your eyes. You can even use the kitchen table to get started. In front of my easel I have a narrow shelf where my palettes sit with a large amount of each color squeezed out and allowed to dry in the paintwells. On a small table nearby, I have my water jug, squeeze bottle and brushes. I keep the 3 or 4 brushes I use most frequently lying on a folded paper towel. With the squeeze bottle, I can easily add water to the paints or the mixing wells as necessary. I often use a maulstick to keep my hand off the wet painting.

I work under color-corrected fluorescent light, which gives consistent illumination whether painting at night or in the daytime. Thus, I am not limited by natural daylight which varies on cloudy or sunny days. I paint from slides and have a rear-projection screen just to the left of my easel. This enables me to easily glance at my subject. I enjoy working from a 16"x20" image as it allows me to observe more detail in the subject. However, pictures work well for many people. My students often paint from enlarged photos with satisfactory results. Some also use a magnifying glass.

Again, remember not to be concerned about having an elaborate setup. Arrange the basics and get started. You can add pieces of equipment and develop your studio as you progress.

Photo: Greg Schneider

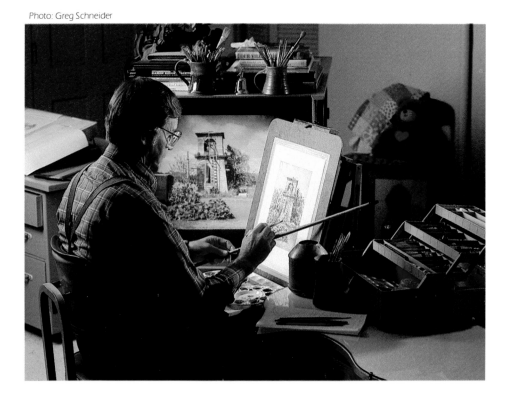

Materials

Photo: Greg Schneider

PAINTS

I use professional watercolor paint which is made in England. The #2 tube is recommended to begin with.

Colors needed:

Cadmium Yellow	Burnt Umber
Yellow Ochre	Cerulean Blue
Cadmium Red	French Ultramarine (blue)
Alizarin Crimson	Viridian (green)
Burnt Sienna	Ivory Black

You will also need a tube of white designer's gouache.

BRUSHES

I prefer 100% nylon (or mock sable) brushes, with white or honey-colored bristles. These soft, springy brushes perform well with my papers. Purchase watercolor brushes #1, #3, #5, #8 for washes, soft-stroking and glazing. You will need #1 and #2 long-haired liners for sketching, fine hatching and daubing.

PAPER

Your paper is the most important element in this system. Do not substitute economy for quality here. Good paper, when quartered, is less expensive per painting and more permanent than water-color board. Its soft, fragile surface allows the paint to "bite in," making it ideal for the multiple coatings used in drybrush. The paint will lie on the surface of inexpensive paper, and "pick up" with numerous washes. Buy the best Italian watercolor paper. It comes in several finishes. Cold-pressed (CP) has a medium texture, rough is coarse, and hot-pressed (HP) is smooth. I use 300 lb., 100% cotton paper which comes in 22"x30" heavy sheets. The paintings in this book were done on quarter sheets of hot- and cold-pressed papers.

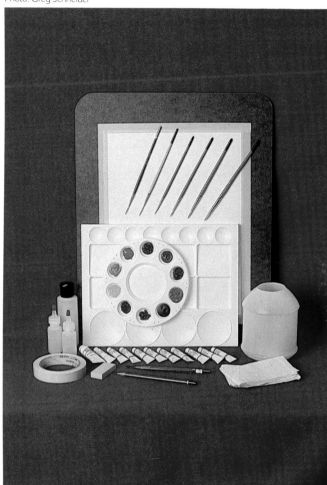

ACCESSORIES

Additional items needed: An "H" **graphite pencil,** a **plastic-type eraser** that won't damage paper, a 16"x20" tempered **masonite drawing board, masking tape,** at least two **plastic palettes,** a small **squeeze bottle,** a quart-sized plastic **water jug,** and **soft paper towels.** A **fishing tackle box** works as a container in which to store my paints and brushes.

NOTE:

Carefully choose light-proof paints and top quality paper of a well-known brand name. Any reliable art store will carry or order these materials for you.

The Monochrome

An effective foundation on which to build some drybrush paintings is the monochrome, a full-valued drawing of one hue. Use this method when more dynamic results are desired. I choose purple for most of mine as there is a bit of this color in everything. Four tones mixed from Ultramarine and Alizarin Crimson, with a touch of black to gray them, are washed over the detailed line drawing, building slowly and thinly, hatching and daubing.

The completed monochrome should have most of the values of a finished painting. Amazingly, the translucent purple will disappear as color is applied. The piece then takes on solidity, and becomes completely transparent, adding depth, vibrance and realism to the paint surface.

Drybrush Strokes Defined

A series of precise strokes used in drybrush is explained here. Your work will be enhanced as you combine them with the washes of traditional watercolor.

Methods of Broken Tone

Softstrokes. Executed with the larger brushes to insure soft, springy action, this almost edgeless stroke is an important complement to the other strokes in developing the graduation of tones. It is used for blending, softening edges, and toning down, and glazing color in concentrated areas.

Daubs. Daubing aids in the blending process of one color into or around another color by creating a succession of isolated or overlapping blobs, giving a mottled, impressionistic or painterly feel to an otherwise "blah" paint passage. A daub can be blotted to lighten, or left as is.

Hatches. An exacting, controlled procedure of building textures, solidity, and depth of tone into a paint surface; hatching is a set of tiny parallel lines, varied in length and direction, which are executed over preliminary washes or under a glaze. Cross-hatching over straight hatching adds variety and fills in areas. From viewing distance, these lines will tend to blend into a solid tone.

Methods of Mass Tone

Light Washes. Light washes are not as flowing as the traditional watercolorist's wash, and are done in a delicate, more detailed manner. I use light washes to lay a foundation on which to build, or for flowing on background patterns wet into wet or wet on dry. They are applied by smoothly moving the fluid back and forth and down the paper, and can be utilized in small or large areas. As the brush runs out of fluid, the tone gets lighter which helps the blending procedure.

Glazes. The glaze, a transparent film of paint similar to a wash, but applied dryer, is laid on with a "wet" brush (see page 10), over other textures and strokes. A glaze is used to darken a tone, tie undercoatings together, and to enrich other colors. It allows the underpainting to show through, adding vigor and vitality.

Sample Strokes

	Light Washes (undercoating)	Glazing (overcoating)
Softstroke (edgeless)		
Daubing (stipple)		
Hatching (fine strokes)		

Broken Tone

All strokes may be overlapped and interwoven.

How to Use Drybrush

Painting is elusive and extremely personal, but there are certain known principles that must be followed to produce a satisfactory piece of work. At this point, let's get down to the details of working with the drybrush system. In this book, I work exclusively with transparent watercolors, with the exception of occasionally combining them with opaque white for final accents.

Preparation

I do not stretch my paper, but tape it to a drawing board, and usually paint on it as is. It buckles slightly when wet, but flattens out when dry.

As shown on page 7, I squeeze out a sizeable amount of the specified colors of paint into my "paintwells" on the palette, then allow them to dry. I arrange the paints in order, from light to dark, so that selection with my brush will become routine. In the vacant wells, I mix color "puddles" by squirting a little water from my squeeze bottle into these "mixing wells" and then adding color from my paintwells, until the correct tone is reached. The less water used, the denser the tone. Other puddles of color are mixed in the center section of the palette. Later, cleanup of the mixing wells is easy with paper towels and a short squirt from my squeeze bottle. At the end of each session, I allow the paint in my paintwells to dry. Next time, I add a little water to moisten the paints, rub my brush across them, repeat the mixing procedure, and I'm ready to paint. I also wash out my water jug and fill it with clean water, letting it stand until my next painting session. This method of preparation is simple and efficient, and doesn't take away from my creating time.

Brush Handling

Your brushes are important to your painting system. Rinse them often while working. Wash them with soap and warm water after each session, and they will last longer.

The brush should become an extension of your arm, instinctive and automatic. Practice makes this happen. A springy, supple brush works well. Use the point for hatching, press down a little for softstrokes, and use the full brush for washes. These strokes are explained on page 8.

There are four degrees of brush wetness in the drybrush system: full, wet, damp and dry.

Loaded with water and paint, the **full brush** is used for flowing a wash across the paper in the watercolor method. I move a puddle of color back and forth and down the page, using my #8 brush for large areas, and my #5 or #3 for shading a subject with light washes. Do not overwork the paper, and let it dry between washes. An electric fan can speed up the drying process. Washes can be worked on dry paper or wet into wet.

The **wet brush,** which is half-filled with liquid, is used for laying a thin glaze of color, tying together some of the underpainting, or for daubing, a stroke used in forming a face or an apple, for instance, or for transitions from color to color. Blotting with a tissue will soften daubed areas. Repeated daubing, accompanied with hatching and softstrokes, gives control. The wet brush, pressed down on the side of the point to get an edgeless stroke, is also used for my softstroke; to blend and round a subject from light to dark.

The **damp brush** is used for hatching and is done with semi-dry brushes, making it a soft technique like that of pencil; although the smaller liners require more liquid to make a better stroke.

The **dry brush** is used for finishing touches. To achieve a "dry" brush, dip it in the paint, stir a couple of times, and wipe the excess on the side of the paintwell. Then, stroke on a soft paper towel to assure a semi-dry brush. I use a small pointed brush for this step, drawing with it as if it were a pencil. This is where the painting becomes very personal, picking out the detail and accenting the final darks.

Proceeding to Paint

The studies beginning on page 14 will show you how to layer colors. First, over the prepared pencil drawing, I lay in light washes using a #8 or #5 watercolor brush for large areas, and a #3 brush for small areas. I work from light to dark, shading the subject in a broad manner, stroking lightly as the brush empties of fluid, keeping it soft and light as I go.

In the next stage, I do more controlled softstroking and light washes, using my #3 brush.

In my final steps, I become more detailed, using my #1 liner for hatching, and doing more controlled stroking. This is where I introduce glazing. You can glaze any color over another color to get the effect you want, and you can tone down an area by glazing with a grayish color. I glaze over my hatching and other strokes to tie colors together. Finally, I accent with small darks, as necessary, at the very last.

In painting backgrounds, remember to use color to "close windows" and "fill gaps" in and around your subject. Also, as you will observe in my examples, the use of abstract patterns helps to accent your realistic areas. More of a mass tone with a few softstrokes and darks is used here. Sometimes I wet the paper for working a wet into wet effect.

These procedures will become more apparent as you progress through the steps in the studies.

Building with Control

You may find that I repeat myself on some of the basic principles. One of these is: remember to build thin layer over thin layer. Multiple coating will give more depth, brighter color and better realism. I cannot stress strongly enough that you must work thinly at first in order to maintain control. Later on you may become more bold. As you build with a series of fine strokes and an occasional wash or glaze to tie it together, you will find your painting gaining atmosphere and translucence. Build slowly. It will look bleached out at first, but as you weave the brush strokes, hatches and thin glazes together; and get used to showing color through color, your piece will take on vibrance. Bring on the color scheme with great care and precision; let the white of the paper do its job — let it show through the paint in places for brilliant color and contrast. This building process will give a professional look to your work.

As you practice applying color, building with control and handling the brushes, you will begin to develop your own personal style of drybrush.

If this system sounds complicated, it isn't! I consider it to be an easy, controllable medium when you proceed with caution, working from light to dark. It is like using a set of drawing tools, only with the terrific advantage of having wet and dry application, and of course, color.

Introduction to Studies

The projects on these next pages are not computerized formulas for you to copy, but are only visual aids — an inspirational guide, really — to show how the picture is developed from line drawing to finish. Please realize that your results may be somewhat different and this is as it should be. For example, the abstract backgrounds will be impossible to duplicate exactly as you see them here. The important thing is to learn the system, but do it your way. I have learned in my relationships with students that I can't say their method is incorrect. You need to start where you are, and to take this instructional guide and carry it on in your own personal style.

Begin your study with a finely detailed line drawing — dark enough to see the lines as you do washes over them, but light enough to disappear as you paint. Proceed with the **Preliminary Color** step, keeping it light and open, and under complete control at all times. Work from light to dark in a precise manner. At first the washes may be so pale the eye can hardly see them. The **Secondary Color** step of shading and modeling should be carried out over the preliminary washes with softstrokes and hatching, daubing with the point of the brush, and sometimes blotting with tissues. You must develop a sensitive touch in handling the paint, making haste carefully.

Finally, the dry brush is used for finishing, picking out the dark accents and details with a small pointed brush; making the thing "pop."

Vary your tones and strokes to avoid monotony. Change a color passage by making it warmer or cooler; gray in one spot, and brighter in another. Accent with some strong darks to bring out the lights. In places, you will want to let the white paper show through the transparent glazes for vibrance and sparkle. Try your hand with the monochrome on some subjects, as explained on page 8.

The wide variety of studies displayed here exposes you to all the colors in the palette. The browns, golds and greens of the acorn contrast nicely with the reds and yellows of the apple and pears. The rag dolls give you an opportunity to practice your blues and reds and reproduce the texture of cloth. The animals and teddy bear allow you to experiment with fur and feathers. The landscape elements give you a chance at nice cross-lighting and use of your earth tones. Finally, the portraits lend great weight to the book as you practice using flesh tones and capturing the likeness of facial features.

I encourage you to begin with the simpler subjects and progress to the more difficult ones as your technique develops. Focus your attention on the "Finish" step, using the other steps only for color reference. Don't give up! Keep practicing! These studies are given to inspire you. In time, with patience, you can teach yourself this innovative system, and develop your own style.

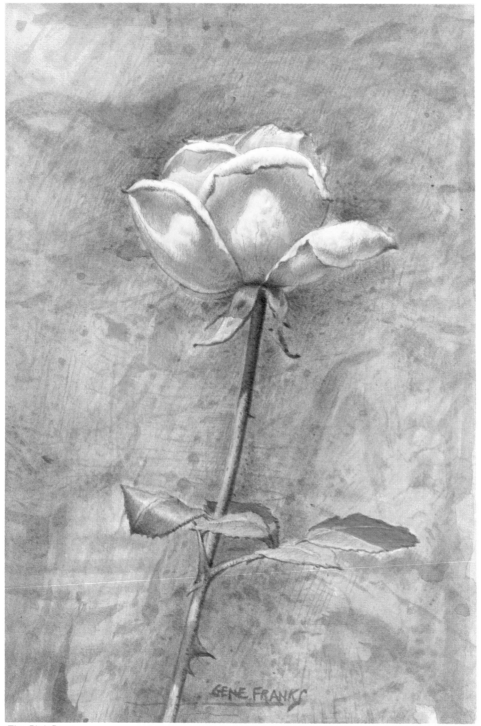

The Pink Rose

Things That Grow

Acorn

Step 1 – With H pencil, develop a detailed line drawing. Outline elements on side of point, rolling the pencil to get thick and thin lines.

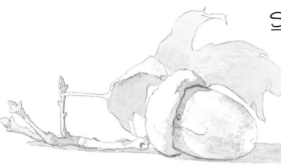

Step 2 – Establish shadows with light wash of Ultramarine, using semi-dry brush and small strokes on acorn. Define leaf, acorn cap and twigs with Yellow Ochre.

Step 3 – Use mixture of Yellow Ochre and Burnt Sienna to bring out the gold of the leaf. Soft-stroke shadowed areas on the acorn with Burnt Sienna and Cad Red.

Warm up buds with a little reddish-orange.

Soft stroke scant background with Cerulean to close gaps around acorn and leaf.

Step 4
Enhance right of leaf with Burnt Sienna. Define green in leaf with Yellow Ochre, Viridian. Cool gold with green behind unfinished cap. Glaze acorn with purple, Alizarin wash. Leave white areas for sparkle. Complete branch with Yellow Ochre, Burnt Sienna. Painted on hot-pressed paper.

Old-Fashioned Delicious

Step 1 - Line Drawing
 Using sharp H pencil,
develop drawing.
Roll the point to
get thick and thin
lines and to show
roundness.

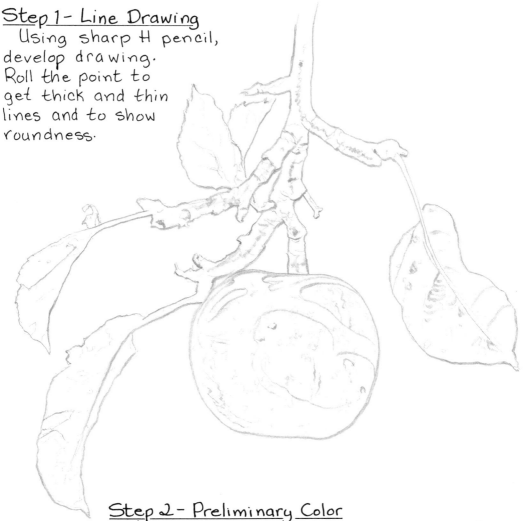

Step 2 - Preliminary Color
 With #5 watercolor brush, wash in <u>apple</u> -- Cad
Red for basic color; Alizarin for accents. Using #1 and
#3 brushes, wash in <u>twigs</u> with Ultramarine. Keep it
light. <u>Leaves</u> are washed in with #5, using Cad Yellow;
Viridian.

Step 3 - Secondary Color
 With #5 brush fairly dry, softstroke shadow on <u>apple</u>.
Hatch detail with #1. Shape <u>apple</u> with Alizarin and Cad
Yellow. Darken and warm <u>twig</u> with Burnt Sienna. Accent
with black and Ultramarine, using #1 brush. Add a touch of
Burnt Sienna to greens to warm upper part of <u>leaves</u>.

Step 2

More yellow on the upper part of the leaf where the sun is shining through.

Accent the Ultramarine wash with Burnt Sienna and Viridian.

Soft stroke Cad Yellow over Cad Red to produce the orangy color at the bottom.

More Viridian in the shadowed areas.

Step 3

Viridian, Burnt Sienna, a little Ultramarine and some Cerulean vary color. Then come in with a touch of black.

Use Burnt Sienna for brown spots on leaves

Alizarin with Cad Red makes a bluer, darker red in spots. Repeated coats bring it into focus and make it convincing.

Step 4 - Finished Painting

Add abstract <u>background</u> using Cerulean for main color with Cad Red and Yellow Ochre for accents. Add lavender mixed from Ultramarine and Alizarin. #8 watercolor brush for large washes; #5 for small accents.

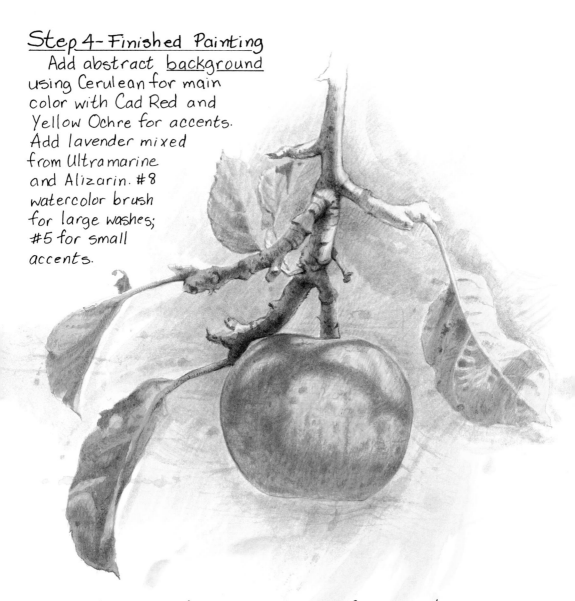

Loose handling of splotches and carefree strokes adds action and color; completes composition. Softstroke, hatch and daub with point of brush, blotting with paper towel.

Thinly glaze <u>apple</u> with damp #5 brush, using red and yellow. Enhance red with thin glazes of Alizarin, using dry #5 brush. Cerulean and Yellow Ochre give greenish look underneath apple.

Use dry #1 liner on <u>twigs</u> with Ultramarine and black for dark accents. Add rosy reds; greens and blues in shadows.

Produce yellow and blue-greens on <u>leaves</u> with mix of Cad Yellow, Viridian, and some black to darken. Painted on hot-pressed paper.

Red Pears

With the H pencil very sharp, lay in drawing, rolling pencil on side of point. Make the lines quite dark to hold up under the washes.

Step 1

Start with pear on right. Lay in Cad Yellow wash. Leave white highlight. Flow Cad Red into areas where red is prominent. Wash Alizarin and some Cad Yellow on left pear. Thin wash of Ultramarine in shadow.

Step 2

With Cad Red, create layers of hatches, small strokes and daubing. Blend Alizarin into darker areas. Add another coat of Ultramarine. Blend green in cast shadow. Define stems with Burnt Umber and black.

Step 3

Step 4

Create abstract background in Cerulean, lavender, brown. Add a few green splotches. Continue to hatch, daub pears. Proceed with more coats of same colors. Blend more green, purple, brown into cast shadow. Add Burnt Sienna under left pear.

Pumpkin Patch

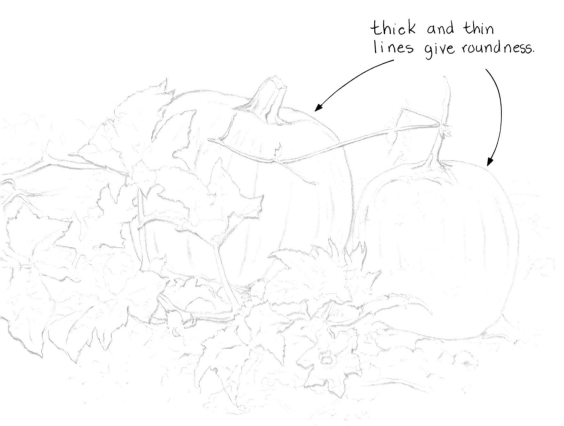

thick and thin lines give roundness.

Step 1 - Line Drawing

Working with H pencil, make rounded pumpkins by rolling pencil on side of the long point to get thick and thin. Identify leaves, stems and thin twig between pumpkins. Refined pencil drawing is important before you begin to paint.

Step 2 - Preliminary Color

Lay in pumpkin wash of Cad Yellow and Cad Red mix. Stem and leaves are begun with Viridian and Cad Yellow washes with touch of Cerulean in greens. Some pale Burnt Umber in darks.

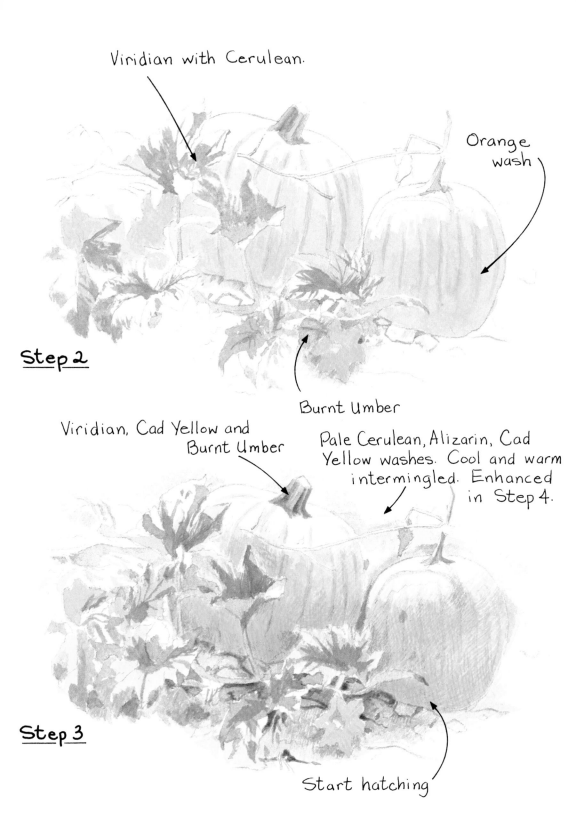

Viridian with Cerulean.

Orange wash

Step 2

Burnt Umber

Viridian, Cad Yellow and Burnt Umber

Pale Cerulean, Alizarin, Cad Yellow washes. Cool and warm intermingled. Enhanced in Step 4.

Step 3

Start hatching

Pumpkin Patch painted on
cold-pressed paper.

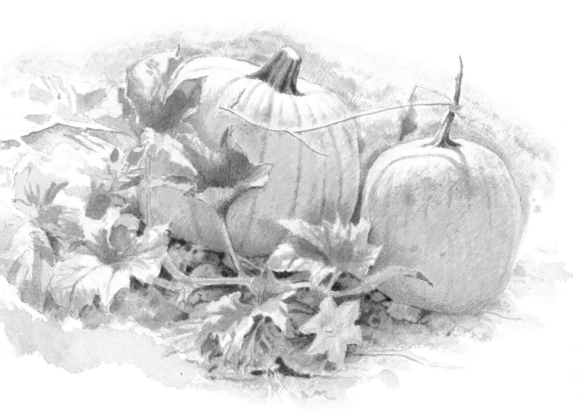

Step 3 - Secondary Color

 Pumpkins: Continue washes of yellow-orange. Define
crevices with Burnt Umber. Add green splotches. Darken leaves
with more Viridian, Cerulean, Cad Yellow. Deepen ground shadow
with Burnt Umber, Cerulean wash. Accent with black. Lay in
blossom with Cad Yellow, Viridian for accents. Start background.

Step 4 - Finished Painting

 Complete pumpkins with softstroking, daubing, hatching. Accent
with Cad Red, Burnt Sienna. Define twigs with Burnt Sienna,
black. Finalize shadows on leaves with Viridian, Cerulean, Cad
Yellow, some black. Intensify blossom with orange detail.
Darken ground with Burnt Umber, Ultramarine, Cad Red. Fore-
ground, bottom left, Cad Red, Yellow Ochre splotches. Pale Ultra-
marine scattered throughout. Touch of Cad Red on right
background.

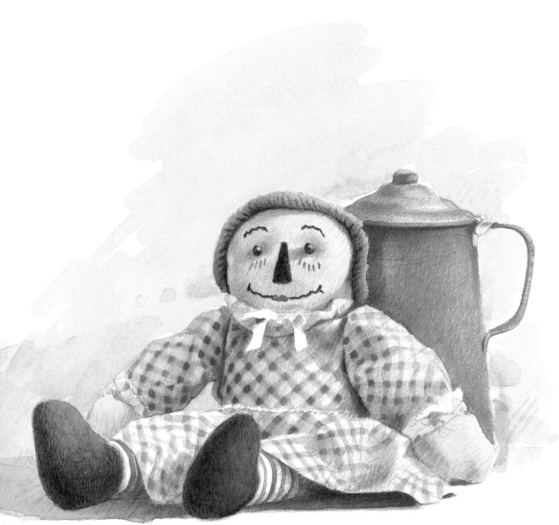

Childhood Companion

Rag dolls with yarn hair and button eyes have endeared themselves to children for many years. One was chosen as "The Classic American Folk Doll" at Expo '67 in Montreal. The homemade versions here and on pages 28-31 find their rightful place in a book dedicated to a gentler, more tranquil time.

Still Life

Coffee Grinder

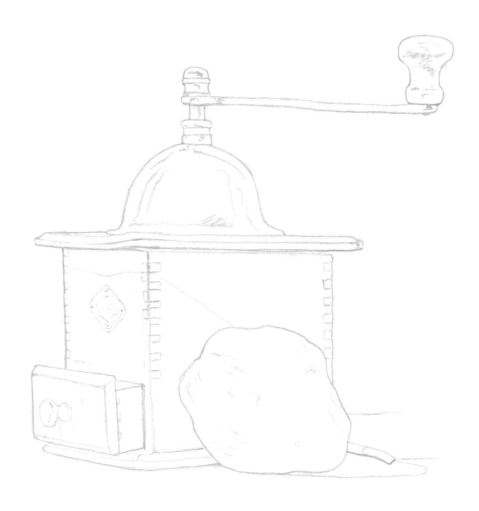

Step 1 - Line Drawing

Develop a very strong, defined drawing, to hold up under washes, with H pencil laid on side of point and rolled for thick and thin.

Step 2 - Preliminary Color

Pick out dark side of coffee grinder and shadowed area of knob on wood handle with Burnt Umber. Indicate silver dome of grinder and metal arm of handle with purple made of Alizarin and Ultramarine. Leave white of paper for highlights at this point. Execute darks of pear with Cad Red wash. Shade in shadow on floor with Ultramarine.

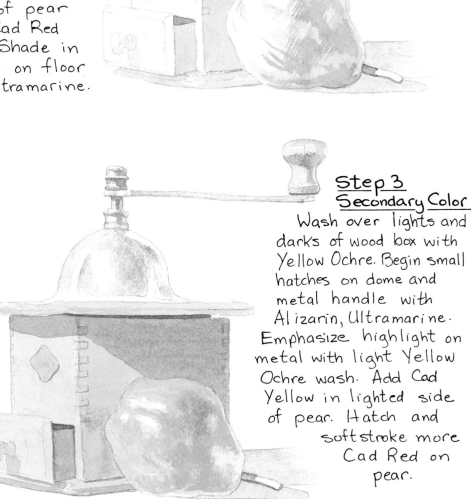

Step 3
Secondary Color

Wash over lights and darks of wood box with Yellow Ochre. Begin small hatches on dome and metal handle with Alizarin, Ultramarine. Emphasize highlight on metal with light Yellow Ochre wash. Add Cad Yellow in lighted side of pear. Hatch and softstroke more Cad Red on pear.

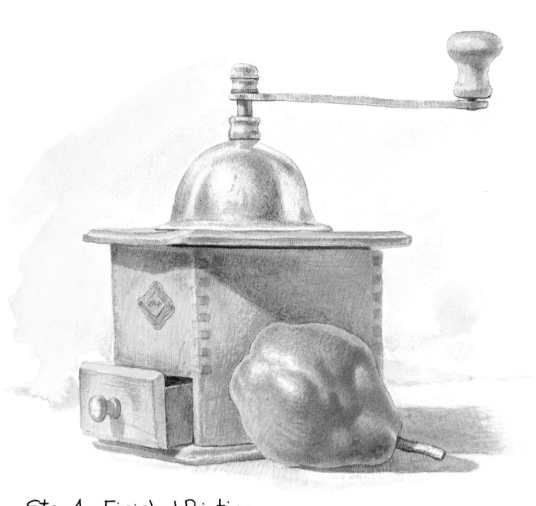

Step 4 - Finished Painting

Float on rich Yellow Ochre/Burnt Umber wash for cast shadow of wood box, and drawer. Add some red. Pick out grain of wood with Burnt Umber. Crosshatch with Burnt Umber, Alizarin, Ultramarine on edges and in shadow. Deepen silver areas with daubing, hatching, softstroking of Ultramarine, Alizarin, black. Glaze Cad Yellow highlights of dome, box, handle, pear. Complete pear by intensifying Cad Red with hatching. Ultramarine, Alizarin splotches on bottom. Lay in stem with Burnt Umber, Yellow Ochre, black. Darken Cad Yellow on side of pear. Leave white highlight.

Shadow on floor intensified with Cerulean, Yellow Ochre washes, purple hatching. Light purple tone laid in to left of pear.

Abstract background of Cerulean, Yellow Ochre loose washes, and Alizarin.

25

Butter Mold

H Pencil.

<u>Step 1</u>

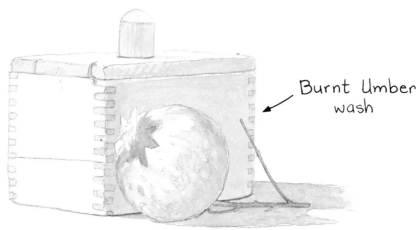

Burnt Umber
wash

<u>Step 2</u>

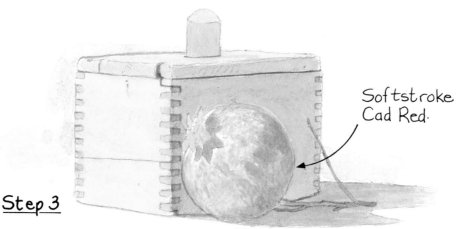

Softstroke
Cad Red.

<u>Step 3</u>

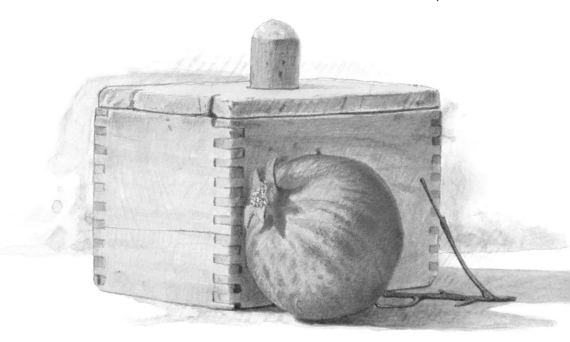

Step 1 - Line Drawing
Use H pencil fairly sharp, rolling on side of the point to get thick and thin, being careful not to damage paper.

Step 2 - Preliminary Color
Pick out darks on twig and butter mold with Burnt Umber. Lay thin wash of Cad Red on pomegranate. Define blue shadow with Ultramarine.

Step 3 - Secondary Color
Lay wash of Yellow Ochre on lighted side of butter mold. Continue Burnt Umber on shadowed side. Daub and hatch to intensify pomegranate, adding Cad Yellow and Alizarin in areas as illustrated. Splotch background with Cerulean and mauve mixed from Ultramarine and Alizarin.

Step 4 - Finished Painting
Add bit of orange in background and on lighted side of butter mold, as illustrated, to give glow and warmth. Enhance with Cad Yellow wash. Indicate wood grain with dark purplish-brown wash. Blue-greens and brown in shadow on floor make pomegranate emerge. Painted on hot-pressed paper.

Rag Doll

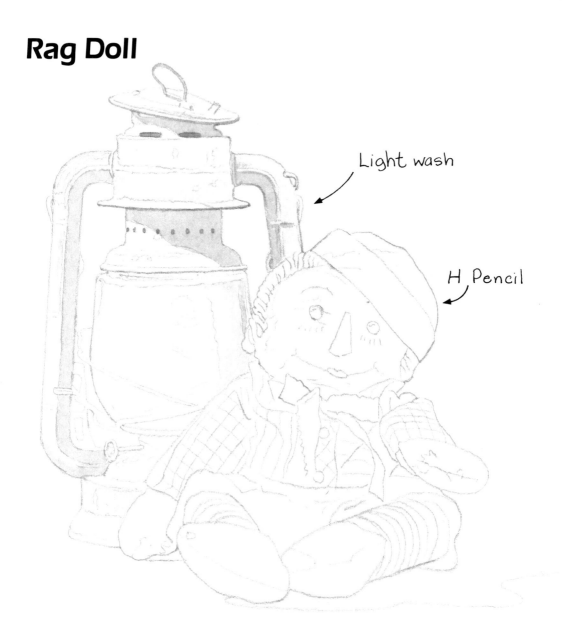

Light wash

H Pencil

Step 1 - Line Drawing

With the H pencil laid on the side of the point, draw subject in heavy lines to stand up under washes. Roll pencil on side of point to get thick and thin. Begin light, thin washes of purple monochrome, mixed from Ultramarine and Alizarin, using #5 brush.

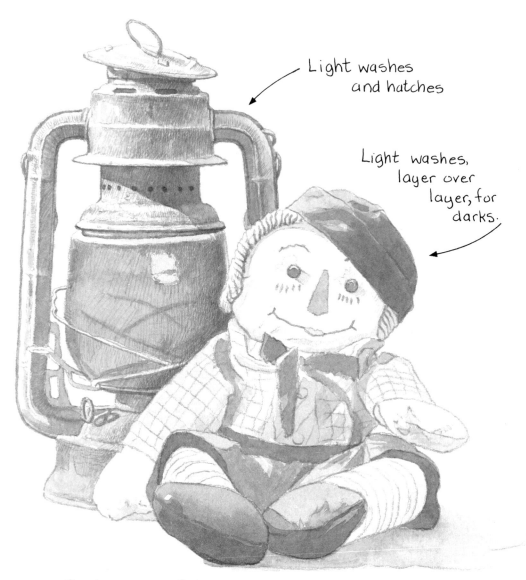

Light washes
and hatches

Light washes,
layer over
layer, for
darks.

Step 2 - Preliminary Color

This full-tone monochrome is developed similar to a pencil drawing with hatches and light washes to achieve form and roundness. Hatches are done with #1 and #3 brushes, and washes with #5. Mix four pools of purple as described on page 10. Continue with light washes. Then come in with some hatching and daubing. Work into it damp or dry. Begin bringing out the deepest darks and cast shadows. Work thin layer over thin layer. This gives atmosphere and allows you to mold and give dimension to the subject.

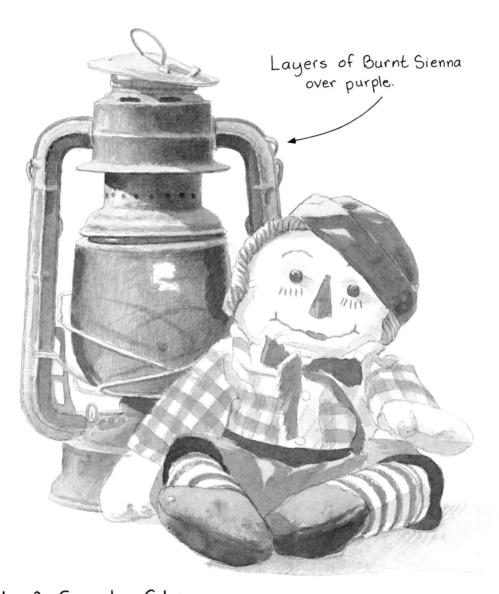

Layers of Burnt Sienna over purple.

Step 3 - Secondary Color

Begin to develop color. On lantern, use Yellow Ochre in highlights. Create rust with Burnt Sienna, Burnt Umber in series of light washes and hatches. Ruby globe is produced with light washes and hatches of Cad Red and Alizarin. Purple disappears during process of coloring. Monochrome underpainting gives painting depth. Red checks in shirt are achieved with Cad Red, thin, making vertical stripe, letting it dry, then making horizontal stripe. Add Cad Red stripes on socks. Highlight shoes with Burnt Sienna. Continue to work purple on hat, shoes and pants. Lay in light orange wash on hair with mixture of Cad Yellow and Cad Red.

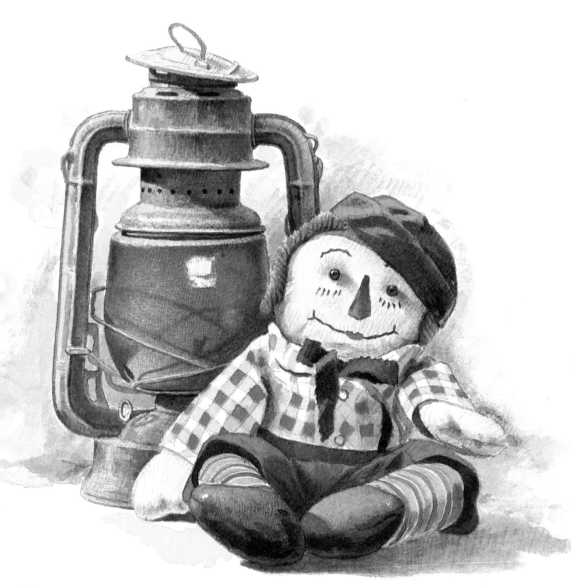

Step 4 - Finished Painting

On lantern, layer Burnt Sienna, Burnt Umber and touch of black. Yellow Ochre, orange in highlights. Hatch layers of Cad Red and Alizarin on globe, touch of Ultramarine for darks. Render hat, pants, tie, shoes, and facial features in dark purple. With Cad Red, enhance mouth and dark squares on shirt. Darken hair with layers of orange. Deepen red, blue and green stripes on socks. Complete face and hands with hatches and softstrokes of Cerulean in shadow, orange and peach in highlights. Leave white of paper in places on face. Cerulean, Burnt Sienna on floor shadow. Yellow Ochre, purple, Cerulean and some Burnt Sienna in background. Fill gaps with Cerulean. Painted on cold-pressed paper.

Teddy

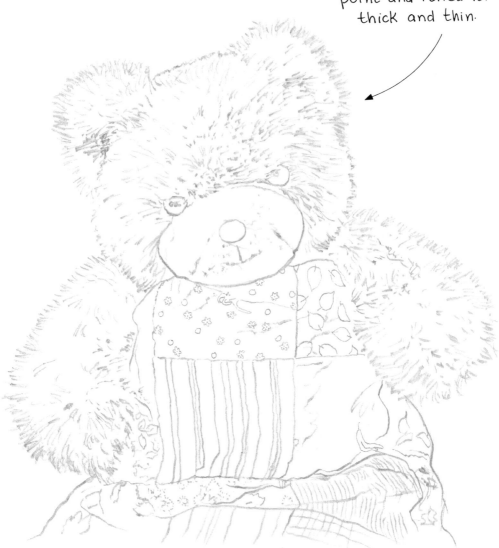

H pencil on side of point and rolled for thick and thin.

Step 1 - Line Drawing

Outline every element of Teddy in detail, strong enough to hold up under his fur and multicolored quilt, yet light enough to disappear under paint washes and strokes.

x x x x x x x x x x x x

The teddy bear, a favorite with people of all ages, from Russia to Europe to America, provides us with a reminder of our childhood and a tie to the past; and for children, an object of security and affection.

Step 2
Preliminary Color

Softstroke, hatch Burnt Umber on fur using #1 and #3 brushes. Flow light washes on quilt with Cad Red, Cerulean, Ultramarine, keeping patterns distinct. Darken eyes with several coats of Burnt Umber. Lightly softstroke, daub face with Burnt Umber.

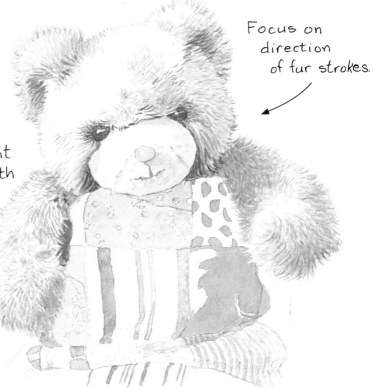

Focus on direction of fur strokes.

Step 3
Secondary Color

Softstroke and daub Yellow Ochre over Umber on fur. Add Cerulean in shadows of face and fur for cool vibration. Lay in shadows on quilt with purple. Darken each color with a touch of black. Add Burnt Umber stripes.

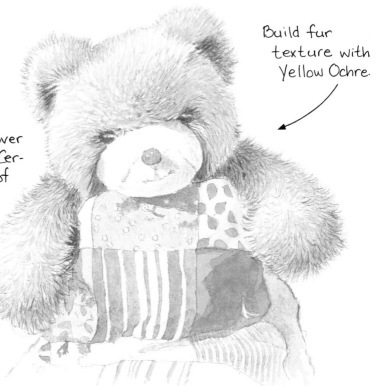

Build fur texture with Yellow Ochre.

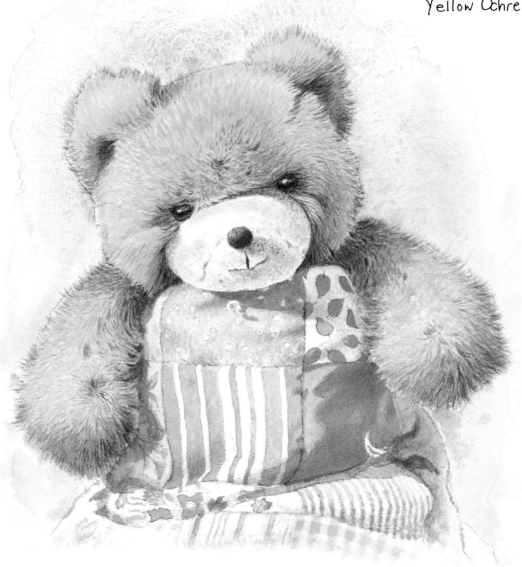

Golden fur brightened
with glazes of
Yellow Ochre.

Step 4 - Finished Painting

Softstroke, daub yellow-orange over brown fur. Hatch, daub peach color on face. Darken eyes, deepen shadowed areas with Burnt Umber, black. Enhance reds, blues of quilt. Accent with yellow and green. Leave white paper in places on face and quilt to add contrast, set off colors. Brighten, complement painting with background wash in purple, Viridian, Yellow Ochre. Wet paper with #8 brush, flow colors in wet, quick, easy. Do some daubing while painting is still damp. Painted on cold-pressed paper for more watercolor effect.

Best Friends

Animals

Rooster

Burnt Sienna for darks.

3.

Pale washes of Cad Yellow, Cad Red, Viridian.

Burnt Umber

2.

Step 3 - Secondary Color
Continue darkening tones, layer over layer. Burnt Sienna over golds in feathers and feet. Add Burnt Sienna hatches to red breast. Enhance brown area above legs with Burnt Umber hatches and touch of red.

Step 2 - Preliminary Color
Begin laying in pale washes from head down--Cad Yellow darkened with Burnt Sienna for golds; Cad Red, Alizarin for reds; black, Cerulean, Ultramarine in tail feathers. Black, Burnt Umber with Ultramarine in darks.

Step 1 - Line Drawing
Refined line drawing made with the H pencil laid on side for thick and thin.

1.

This multicolored guy, a mixed breed, with a wonderful strut, captured my attention. His colors are a delight. He is painted on hot-pressed paper.

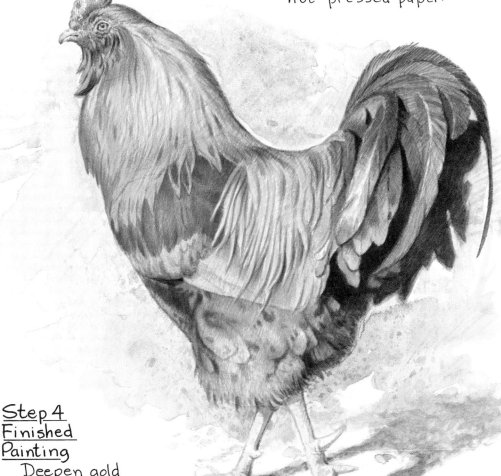

Step 4
Finished
Painting

Deepen gold with Cad Yellow, Burnt Sienna hatches and softstrokes. Add some Burnt Umber, Cad Red to brown area above legs. Mold feet and shoulders with Burnt Umber over golds. Intensify red breast with Burnt Sienna, Cad Red hatches and washes. Amplify iridescent tail feathers with softstrokes, washes of Cerulean, Alizarin, Burnt Umber and black. Hatch over washes for feather pattern.

Wash in background of Alizarin, Ultramarine, Cerulean and Yellow Ochre, as illustrated. Shadow of rooster is made of Cerulean, Viridian and black. With #5 brush, "flick" in some splotches by shaking brush over paper. Also add some daubing.

English Lop

H laid on side
for thick and
thin lines.

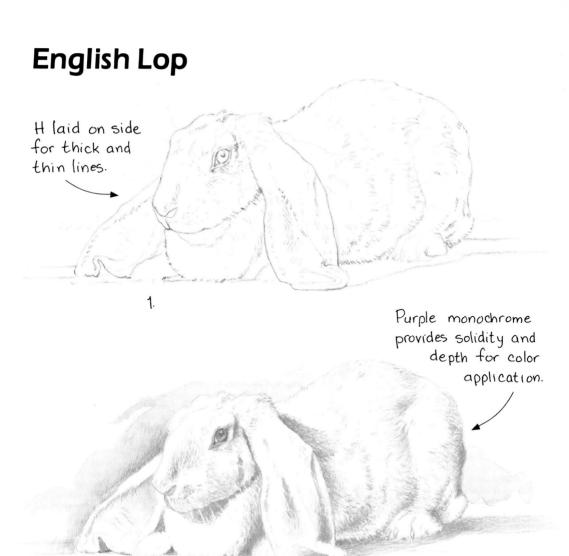

1.

Purple monochrome
provides solidity and
depth for color
application.

2.

Cool background
against warm
rabbit.

Burnt Sienna
on rump.

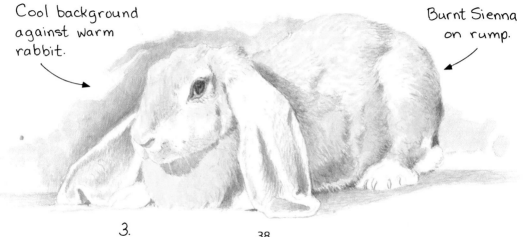

3.

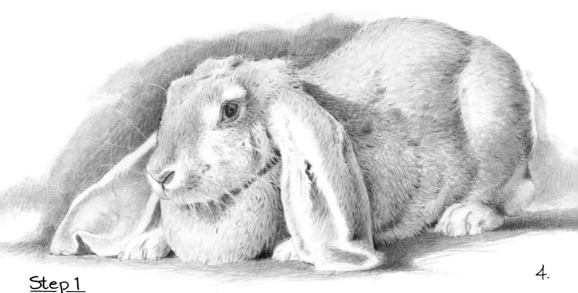

Step 1

With H pencil, work line drawing, defining areas of detail as you go. Make it strong enough to be seen under preliminary wash.

Step 2

Render toned drawing in purple, mixed from Ultramarine and Alizarin, using #1 and #3 brushes. Establish shadows, darks and lights softly so they can be painted over. Show white areas around eyes and on ears. Work very pale at first, since rabbit is light in color and tone. Darken background with deeper purples to add contrast behind head and ears.

Step 3

Establish rabbit in pale Yellow Ochre and touches of Burnt Sienna in places, as illustrated. Keep it pale and thin. Work over dark purple in eye with Burnt Sienna. Lay in Cerulean and Viridian in background over purple. Use #1 and #3 brushes for fur, coming up on point for fine lines and pressing a little harder for soft stroke and daubing.

Step 4

Deepen Yellow Ochre with purple and Burnt Sienna to achieve bleached coppery look. Leave eye, front of ears, part of face and feet white. Darken shadow on pouch with green, blues, warm browns. Define cast shadow across rabbit with blue, green, purple over brown hatches. Complete ears with Alizarin and purple. Add a few whiskers using opaque white, with #1 long-haired liner.

39

Piggin' Out

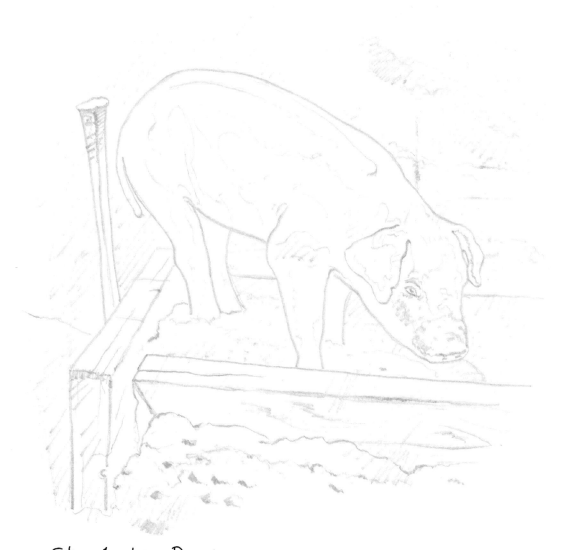

Step 1 - Line Drawing

Lay in precise line drawing with H pencil on side of the point. Roll for thick and thin. Bold lines will show through washes.

This little fellow was one of a litter of twelve. We found him with his siblings at the County Fair, and he seemed to really enjoy getting into his meal!

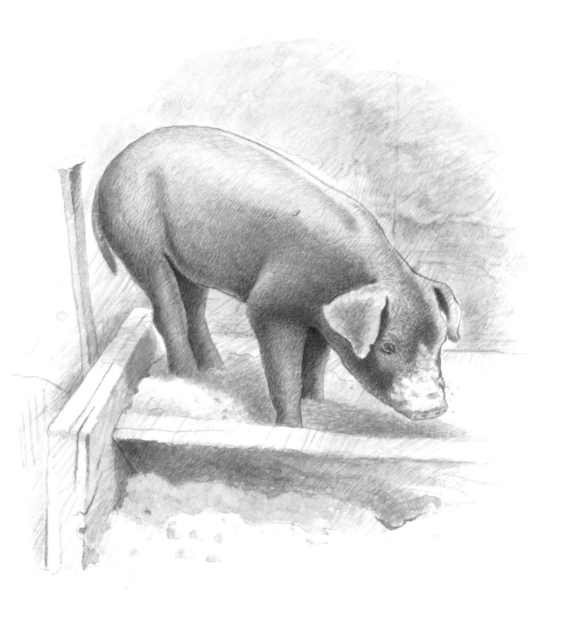

Step 2 - Preliminary Color

Develop the purple monochrome, using a mixture of Ultramarine and Alizarin with a touch of black to gray it. Use hatches and light washes to achieve form and roundness. Work thin layer over thin layer to give atmosphere and dimension. Hatches are done with #1 brush, and washes utilize #3 and #5 brushes.

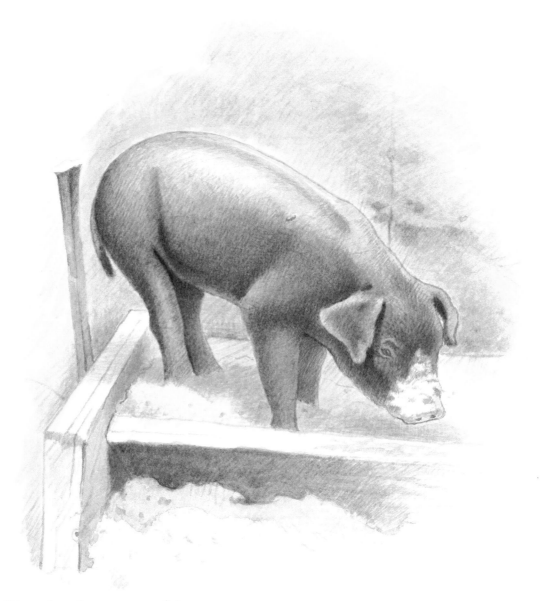

<u>Step 3 - Secondary Color</u>

 Begin to color monochrome. Pig is executed in Burnt Sienna toned with Alizarin. Use #3 brush, damp, in true drybrush method, softstroking and daubing on side of point. Delicately lay in reddish shades over purple tones, thin layer on thin layer, being careful not to put it on too wet so that you won't loosen up underpainting. Hatch to help mold pig. Vivid, raw purple will change to reddish brown as you lay in your color. Define background and feed in trough with pale Cad Yellow. Add light Viridian washes to background, as illustrated.

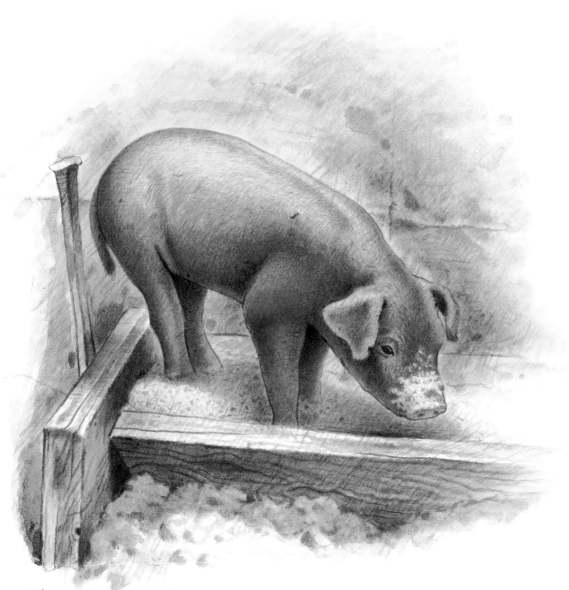

Step 4 - Finished Painting

In background, work Cad Yellow around animal to give glow. Use grayish-purple in darks. Softstroke Burnt Umber in browner splotches, and Cerulean on outer edges. Daub with Cerulean splotches. Create wood on trough with bluish-grays over purple. Continue with Ultramarine and black. Warm up areas with Burnt Sienna and Yellow Ochre. Food in trough is mixture of Burnt Sienna, Yellow Ochre, with Cerulean in shadow, glazed with thin black. Interlace glazes of warm color over cool. Incorporate Cerulean splotches on side of pig and under his eye to give relief from warm areas. Use gray and Cerulean on metal stakes. Painted on hot-pressed paper.

Donkey

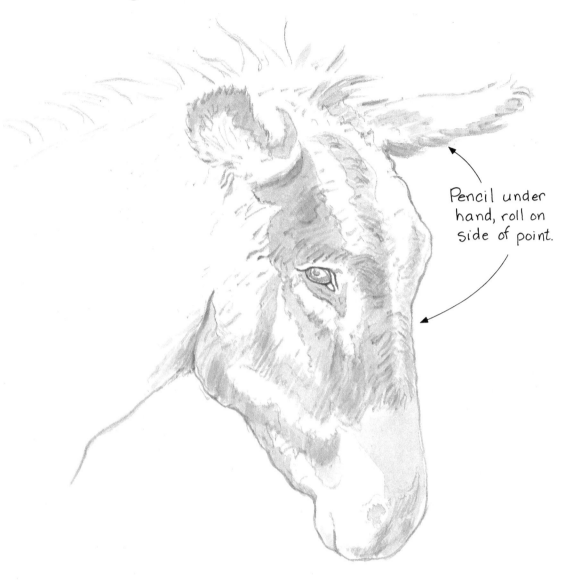

Pencil under
hand, roll on
side of point.

Step 1 - Line Drawing

Establish detailed line drawing with H pencil. Lay in
thin mixture of warm gray composed of black and Alizarin.
Using #5 watercolor brush quite dry, define cast shadows and
dark areas. Soften edges as you go. Pick out sections around
eyes and nose. Delineate lines and tufts in his straggly mane
and fur.

Thin Burnt Sienna
wash in dark places
over mauve.

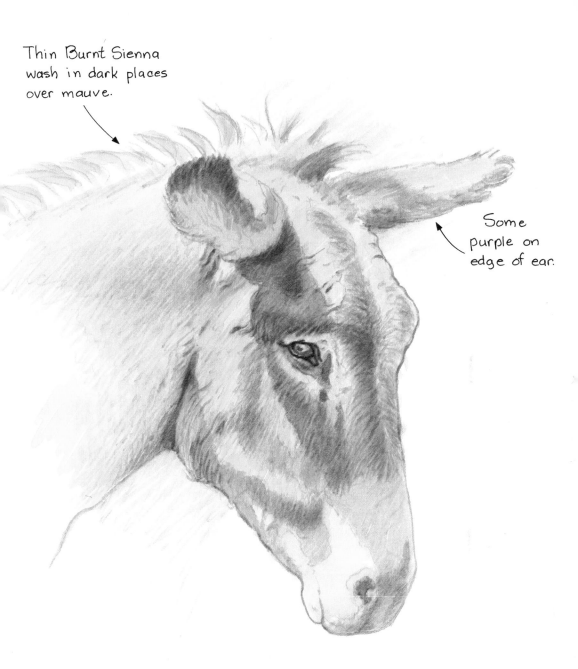

Some
purple on
edge of ear.

Step 2 - Preliminary Color

Lay in Yellow Ochre washes very thinly in the highlighted areas. Add coats of warm gray in the shadowed sections. For the shadow across the nose, near the jaw, and around his eyes, shade in a very pale wash of Ultramarine Blue.

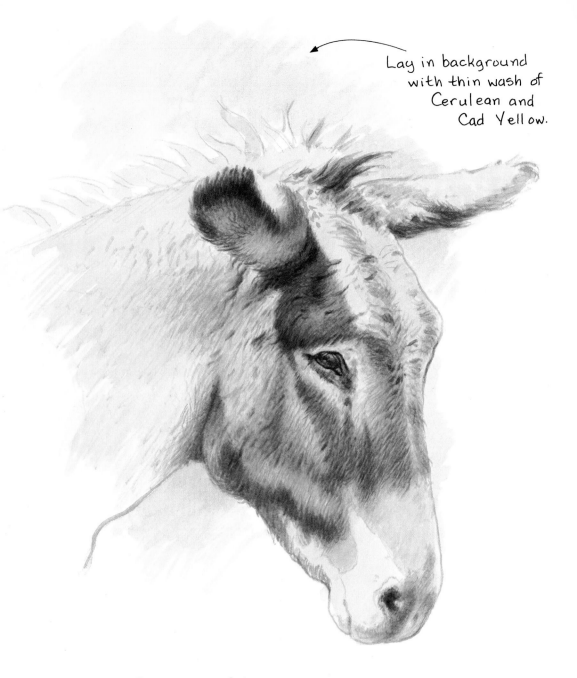

Lay in background
with thin wash of
Cerulean and
Cad Yellow.

Step 3 – Secondary Color

Build texture with continuous process of stroking, hatching, and running thin glaze over hatches -- repeat back and forth. Pick up fine detail of hair with #2 long liner. Mix four pools of color: Yellow Ochre very thin, Burnt Sienna, purple mixed from Ultramarine and Alizarin, and Burnt Umber with a little Alizarin to warm up the browns. Alternate back and forth among these four colors. Use #1 and #5 brushes for washes, and #2 long liner for hatches and line work.

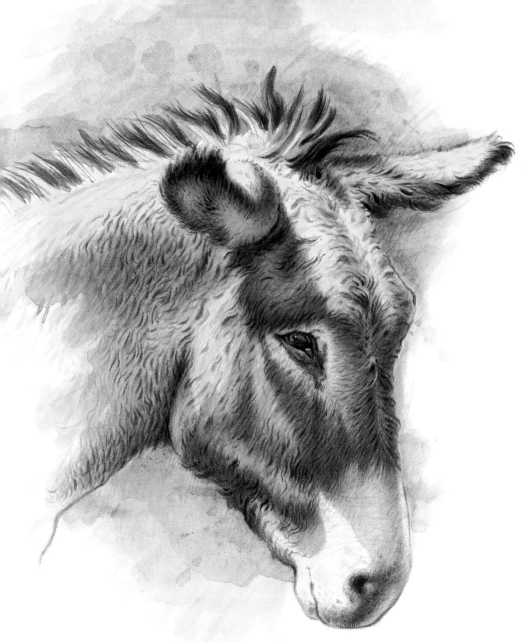

Step 4 - Finished Painting

Work Burnt Sienna and Burnt Umber into dark brown areas.
Glaze lighter areas with Yellow Ochre. Mix Alizarin, Ultramarine
and black for dark highlights on mane, ears, jaw and nose. Glaze
near ear and forehead with orange (Cad Yellow and Cad Red). Add
touch of Cerulean to shadow on nose. Work Burnt Sienna, purple,
Cerulean, grayed black and Alizarin into green background. Com-
plete with Cerulean accents and purple splotches. Combine mix-
ture of washes, hatches and softstrokes with #5 brush. Background
adds action, and cool colors recede behind donkey. Painted on
hot-pressed paper.

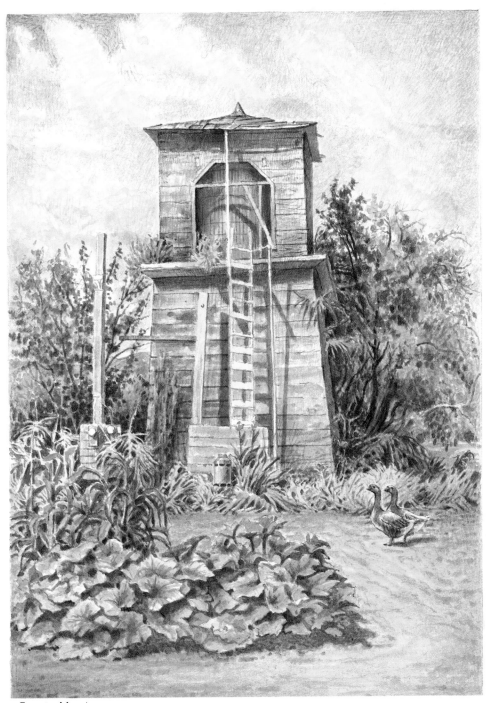

Country Morning

Landscape Elements

Cooley's Ranch

Step 1 - Line Drawing

Develop pencil drawing with H pencil laid on side and rolled for thick and thin.

Built in 1862, Cooley's Ranch was one of Southern California's finest ranches. I drew and painted it many times, on site. The old place spoke to me of my country childhood. It's gone now, and I happily did this painting from one of my slides taken in its last days.

Use #3 and #5 brushes for washes;
#1 for lines and
hatches.

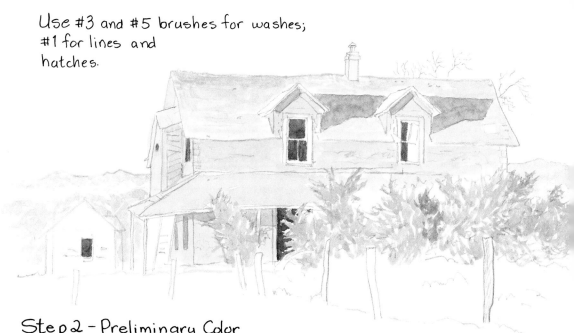

Step 2 - Preliminary Color

On roof, lay in purplish-brown mass tone of Burnt Umber, Alizarin and Ultramarine. Wash in dark shadows on roof with Ultramarine and black. Highlight building with Yellow Ochre wash. Windows are Burnt Umber and black. Indicate trees with Viridian and Cad Yellow. Execute mountains in light Ultramarine wash.

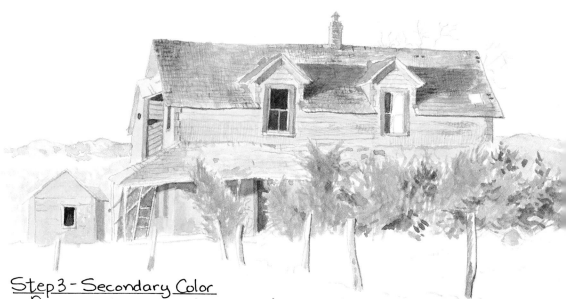

Step 3 - Secondary Color

Proceed with purplish-brown roof in small hatches. Get dark where shingles are missing. Softstroke Cad Red for variance in color on roof and chimney. Continue with browns in windows and on boards on side of house. Develop trees, using Viridian, black and Ultramarine. Accent fence posts with Ultramarine, black. Deepen Ultramarine on mountains. Lay in small shack with Burnt Umber.

Step 4 – Finished Painting

Interlace hatches and softstrokes in roof. Enhance blue shadows on roof with Ultramarine and Cerulean. Darken red on roof and around chimney. Make windows darker with black, Alizarin. Richen gold tones on building using Cad Yellow. Cool shadow under porch roof is achieved with light brown and Cerulean over it. Hatch and pick out the darks of porch roof with Alizarin and Ultramarine. Make trees denser with Yellow Ochre and Viridian. Add touches of Cad Red, black, Ultramarine. Grass in foreground is executed quickly in loose, immediate washes of Viridian and Yellow Ochre, with smattering of Alizarin and splotches of Viridian intermingled. Lay in telephone pole with purple. Glaze with reddish-brown, Ultramarine in the darks. Build up multiple coatings on shack, of Burnt Umber, Alizarin, Ultramarine. Done with #1 brush laid on side.

Complete splotching and softstroking mountain with Ultramarine, Alizarin, Yellow Ochre. Glaze with Cerulean.

Cooley's Ranch has the sunlit look, achieved by deep darks and cast shadows. This is a classic example of tight and loose application. Painted on hot-pressed paper.

Caboose

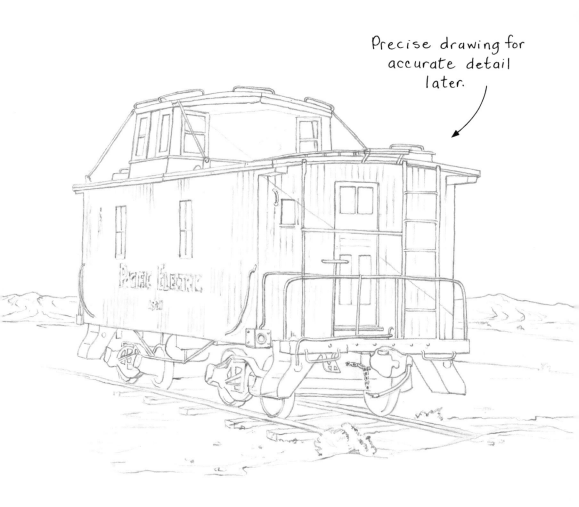

Precise drawing for accurate detail later.

Step 1 - Line Drawing

I used an H lead in my drafting pencil to do this very mechanical drawing. The point was kept sharp with a lead pointer. Carefully outline railings, wheels and windows. Also lay in desert floor and mountains.

Step 2 - Monochrome

Lay in purple monochrome of Ultramarine and Alizarin using #1 liner for fine lines and #3 brush for light washes and softstrokes.

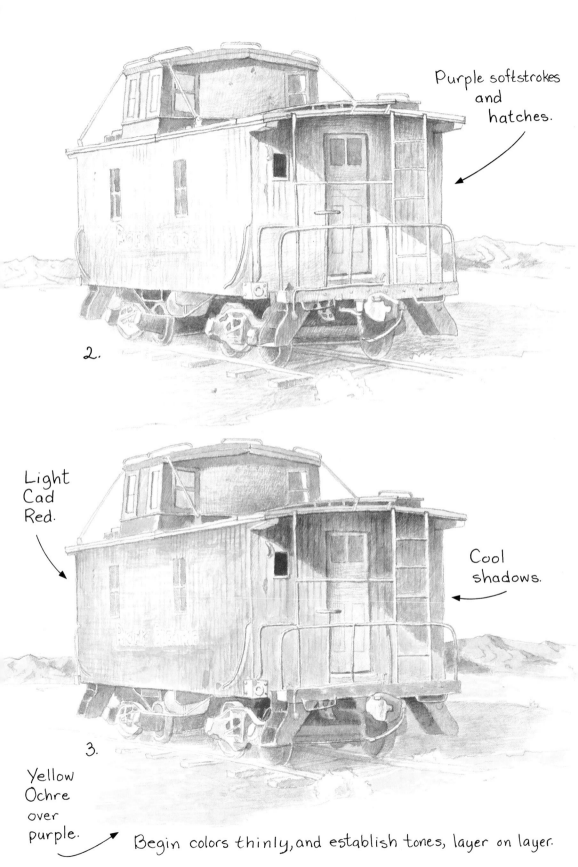

Purple softstrokes
and
hatches.

2.

Light
Cad
Red.

Cool
shadows.

3.

Yellow
Ochre
over
purple.

Begin colors thinly, and establish tones, layer on layer.

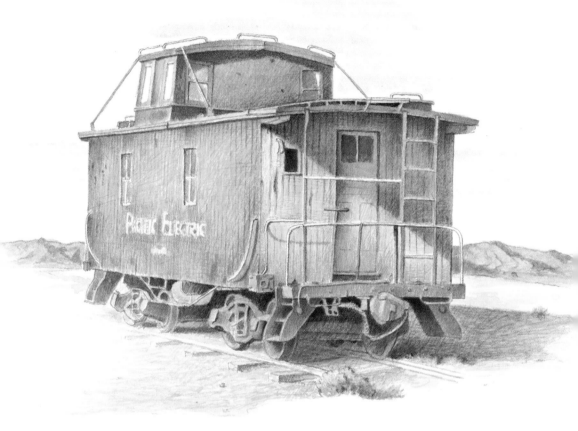

Step 3-Secondary Color

Over purple monochrome, lay in light washes, softstrokes of Cad Red, Cad Yellow, mingled in lighter areas for orange effect. Use #1 and #3 brushes. Add Cerulean, Viridian, Burnt Umber in shadow. Cut around railings to finish later. Tone desert floor with pale Cad Yellow and Burnt Umber washes, Cerulean in shadows. Indicate mountains in Burnt Umber and purple.

Step 4 - Finished Painting

Continue with softstrokes and hatches of above colors on all elements. Add Viridian, Cad Yellow to bushes on desert floor, and Burnt Umber to railroad ties. Indicate wheels with Burnt Sienna, Cad Red washes, hatches. Bring in darks with purple and black. Add sky with Cerulean wash, softstrokes. Painted on hot-pressed paper.

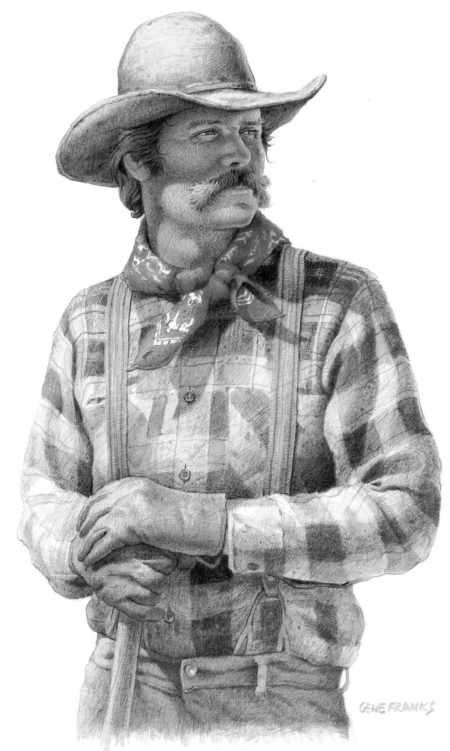

"Inherit the Land"

GENE FRANKS

Portraits

Annie

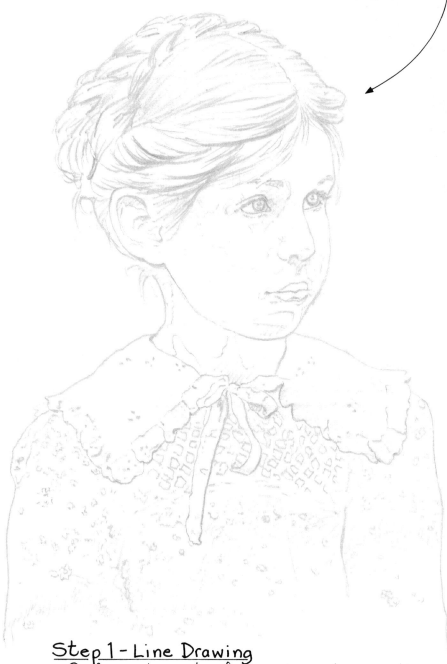

H pencil held flat and rolled.

Step 1 - Line Drawing
Define elements of face, hair, dress pattern in refined drawing. Use H pencil on side of point for thick and thin strokes.

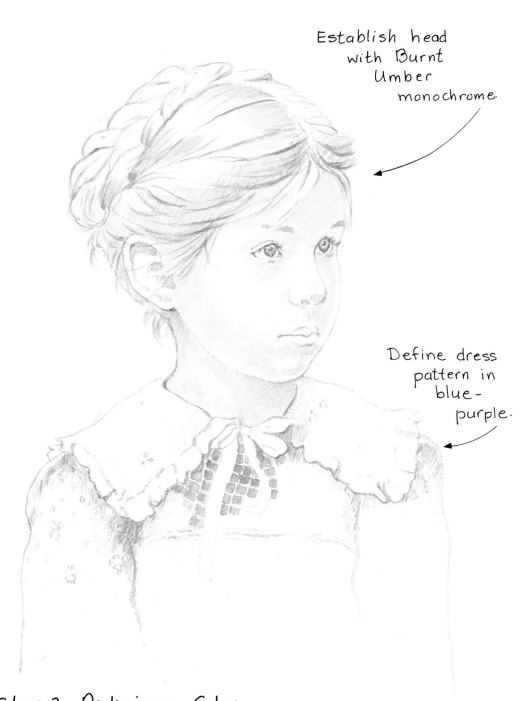

Establish head
with Burnt
Umber
monochrome.

Define dress
pattern in
blue-
purple.

Step 2 - Preliminary Color

Feel structure of face and hair with Burnt Umber light wash, softstrokes using #3 brush. Begin dress detail with mix of Ultramarine, Cad Red. Mimic pencil drawing with #1 liner.

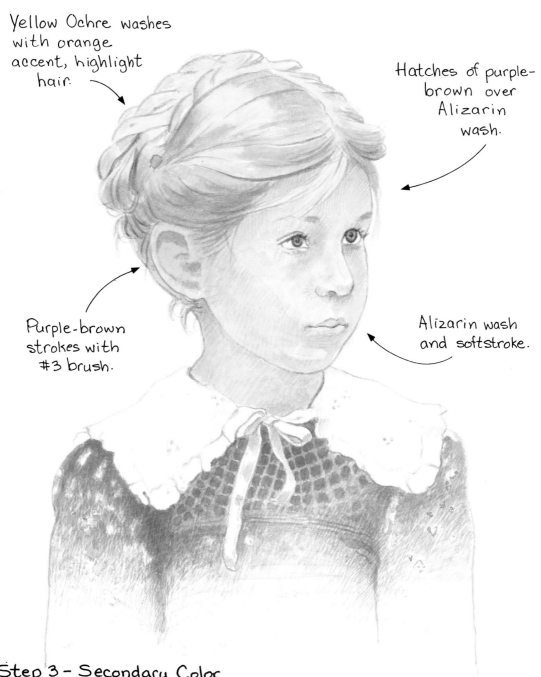

Yellow Ochre washes
with orange
accent, highlight
hair.

Hatches of purple-
brown over
Alizarin
wash.

Purple-brown
strokes with
#3 brush.

Alizarin wash
and softstroke.

Step 3 - Secondary Color

Softstroke layers of Alizarin, Burnt Sienna, Ultramarine on face
with #3 brush; Yellow Ochre in lights; fine hatches with #1 liner
mingled in. Softstroke mixture of Burnt Umber, Alizarin, Ultramarine
for darks in hair. Deepen with black. Medium tones are Burnt Umber,
Cad Red. Continue blue-purple on dress with hatches and soft-
strokes. Add pale Cad Red ribbon.

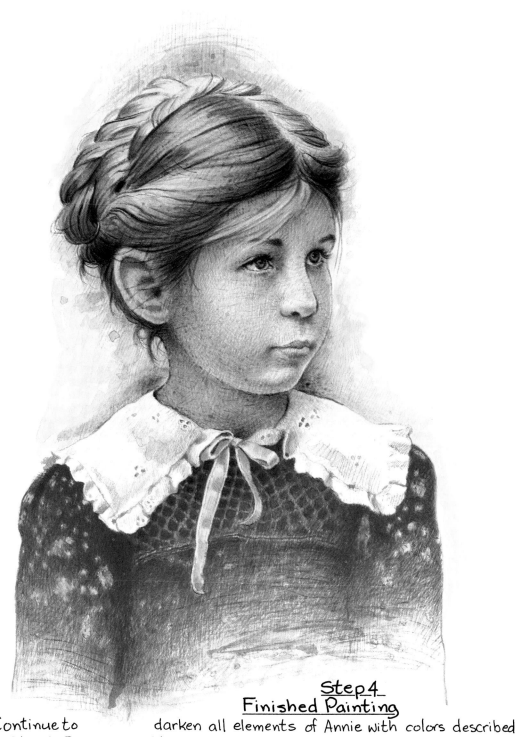

Step 4
Finished Painting

Continue to darken all elements of Annie with colors described in Step 3. Darken with black where needed. Multiple coats of hatching, soft-stroke on face. Deepen eyes with Ultramarine. Complete dress with deep Ultramarine hatching, softstrokes. Add pale Cad Red for flowers and ribbon. Pale purple shadows on collar. Background washes, daubs of Cerulean, Cad Yellow, Alizarin accented with purple and brown hatches.

Lucky

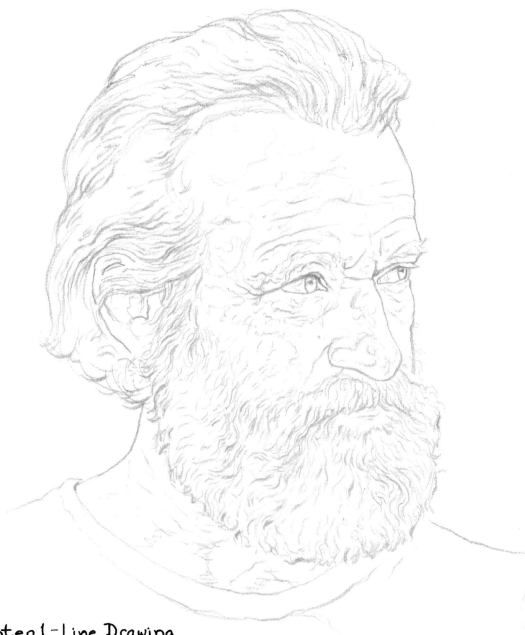

Step 1 - Line Drawing

Use the H pencil nice and
long, sloped and sharp on the point. Roll
the side of the pencil point to get thick
and thin. A strong, expressive drawing will
show roundness and solidity; and give good artistic feeling.
It is important to work out this foundation in detail before you
start to paint.

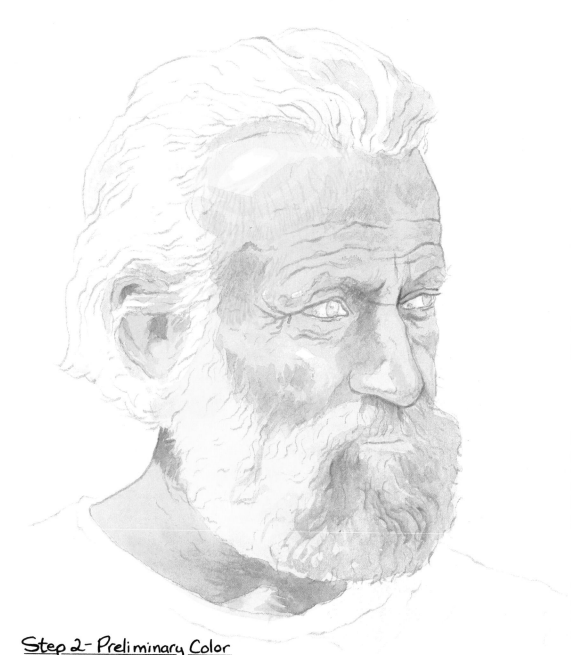

Step 2 - Preliminary Color

Explore shadow on face and hair with light purple wash (Alizarin and Ultramarine). Come in with Cad Yellow on forehead and beard on lighted side of head. On shadowed side, wash over purple with Alizarin for flesh tone in shadow. Add Cerulean and green (Viridian and Cad Yellow) to beard. Define neck with Yellow Ochre and Burnt Sienna over purple.

61

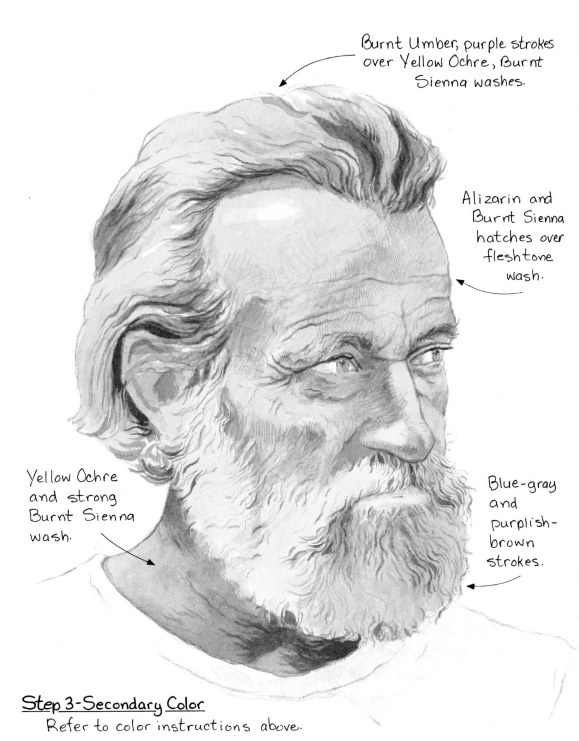

Burnt Umber, purple strokes over Yellow Ochre, Burnt Sienna washes.

Alizarin and Burnt Sienna hatches over fleshtone wash.

Yellow Ochre and strong Burnt Sienna wash.

Blue-gray and purplish-brown strokes.

Step 3-Secondary Color
Refer to color instructions above.

Step 4 - Finished Painting
Continue Yellow Ochre, Burnt Sienna washes in hair. Cerulean in shadows. Hatch light orange over lighted side of face. Deepen shadowed side with Burnt Sienna, Cad Red softstrokes and hatches. Softstroke Burnt Sienna, Cad Yellow, Alizarin on nose. Glaze light Yellow Ochre for

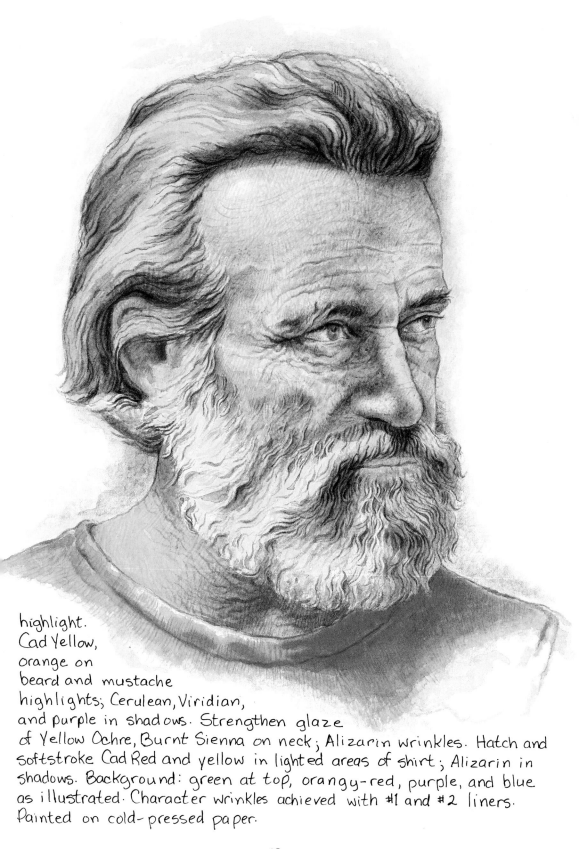

highlight.
Cad Yellow,
orange on
beard and mustache
highlights; Cerulean, Viridian,
and purple in shadows. Strengthen glaze
of Yellow Ochre, Burnt Sienna on neck; Alizarin wrinkles. Hatch and
softstroke Cad Red and yellow in lighted areas of shirt; Alizarin in
shadows. Background: green at top, orangy-red, purple, and blue
as illustrated. Character wrinkles achieved with #1 and #2 liners.
Painted on cold-pressed paper.

Final Thoughts

In a world of glutted markets, I'm thankful to God for this refreshing vision of another way of looking at watercolor.

I'm grateful to Walter Foster Publishing for allowing me to share this body of work with other art enthusiasts.

Many thanks to my students and friends who helped supply me with subjects for this collection and critiqued my paintings.

My heartfelt love for others who prayed for me.

To my faithful wife, Jane, who helped me organize and plan the flow of this volume; who compiled, condensed, edited and re-edited my thoughts and the written copy; who wrote the foreword and hand-lettered all the studies, I lovingly dedicate this book.